How to Enjoy Poetry

Frank Skinner is an award-winning comedian, television and radio host, author and podcaster. Since winning the prestigious Perrier Award at the Edinburgh Fringe in 1991, Frank has gone on to create and present TV shows including *The Frank Skinner Show*, *Frank Skinner's Opinionated* and *Room 101*, as well as write two best-selling memoirs, win three gold awards for his Absolute Radio show, and co-host Fantasy Football and Baddiel & Skinner Unplanned with David Baddiel. Spring 2020 saw him successfully launch Frank Skinner's Poetry Podcast with Absolute Radio, and his stand-up show 'Showbiz' enjoyed a sold-out national tour and West End residency.

Other titles in the series:

How to Play the Piano by James Rhodes
How to Land a Plane by Mark Vanhoenacker
How to Be 'Normal' by Daniel Tammet
How to Skim a Stone by Ralph Jones
How to Climb Everest by Kami Rita Sherpa

Little Ways
to live a
Big Life

How to
Enjoy
Poetry

Frank Skinner

Quercus

First published in Great Britain in 2020 by

Quercus Editions Ltd
Carmelite House
50 Victoria Embankment
London EC4Y 0DZ
An Hachette UK company

A CIP catalogue record for this book is available from the British Library.

ISBN 978 1 52941 296 3
Ebook ISBN 978 1 52941 297 0

10 9 8 7 6 5 4 3 2

Text designed and typeset by CC Book Production
Printed and bound in Great Britain by Clays Ltd, Elcograf S.p.A.

Contents

Introduction

Yes, I enjoy poetry. Not *all* poetry, obviously. I make that point because you may have encountered poetry in your life that has left you completely cold, and thereby decided that the whole genre was not for you. That was foolish. That is like resolving to avoid all chorus girls because one was beastly to you at the Bradford Alhambra in 1992. Look, you've got your similes, I've got mine.

When I was doing an English degree at Birmingham Polytechnic in the eighties, a family member said to me, in a someone-needs-to-tell-you-this tone, 'You know, the family think you're a weirdo, reading poetry and wearing a [*pause*] Shakespeare badge.' Maybe, looking back, the badge *was*

a bit embarrassing, but the 'reading poetry' remark stuck with me. I guess it was the kind of conversation that happens when someone from a working-class background starts getting fancy ideas. The poet John Betjeman said education enables one to feel at home anywhere, except at home. If my passion had been, say, mathematics, a more worldly discipline, I think I'd have been OK. I may have even got away with a Fibonacci badge, but it was the effete nature of poetry that made me, suddenly, the exotic bird amidst the sparrows.

Poetry lovers are viewed with suspicion. Many years later, when a popular tabloid was trying to convince its readers that they had identified a sexually motivated murderer, their character-assassination Exhibit A was 'He owns over a thousand books, many of them poetry'. So, if you are into poetry or, better still, if this book gets you into poetry, best keep quiet about it. Being a poetry lover is like being a Christian. It might be a defining aspect of your entire being,

but still be careful who you tell. I must confess, I read or listen to poetry every day but, despite that, if someone tells me they like poetry, I either don't believe them or I immediately strike them off my babysitter list. As I say, it's like being a Christian.

Anyway, why are we here? Well, I want to look at a poem, in some detail, and share the experience with you. Many years ago, I was offered a part in a West End play. I was scared because it was a big part and featured a massive speech that went on, page after page. I phoned my brother for advice. Should I take the part? He was a sheet-metal worker at the time, but I wasn't looking for Stanislavsky quotes, just a few wise words. He pointed out that the speech would be like eating an elephant: one mouthful at a time.

So, I did the play and it went great – and that's how I approach poems. The entire elephant of even a short poem can be a daunting proposition. People are inclined to withdraw at the first sign of gristle, but I like to chew and chew. You know how some people

become distressed when they hear fingernails on a blackboard or watch someone remove a contact lens? Well, that's how I feel when I skim-read a poem. The horror of just moving along the lines, never stopping to multi-think a phrase or an idea, never readjusting the focus from sentence to structure, from meaning to metre – it honestly makes my stomach knot.

Every time you enter the intricate edifice that is a really good poem, you keep finding more doors, more rooms you weren't expecting, a stronger feeling of why the poem was built the way it was, and the increasing joy of your own ever-developing individual response to it. I don't want to drop by, I want to inhabit. One minor example of a poem continuing to grow for me is, on my fortieth or so reading of Philip Larkin's 'Church Going' over several years, I finally realised the title included a pun on the disappearance of organised religion, the core-theme of the poem.

Someone recently said to me, in reference to my

poetry podcast, that you'd think poetry would be more popular than ever, in the twenty-first century, because people don't have a lot of time and 'novels are often quite big, while poems are often quite small'. I referred them to *Doctor Who*'s Tardis. Poets really think about word-choice and complementary sounds and changes of pace and massive ideas and tiny details, and so to read a poem with anything other than rapt attention is to disrespect both it and yourself. So, in this book I'm focusing on a single poem, because the alternative was to look at more poems, less.

The prose comparison is interesting, though. Judging by what I see on public transport, a lot more people read prose than poetry. In fact, if I'm basing an opinion on that criterion, I'd say nobody reads poetry. Prose is easier. I know people say they love novels because they get to create, with the writer's help, the characters and locations in their own imagination. This gives them an intimate relationship with the book, which is why people often see a

film adaptation of a novel they have that emotional attachment to and say, 'I preferred the book.'

But poetry is in a different league. Just look at a page of poetry. It's an environmentalist's nightmare. There's unused paper all over the place. This represents our side of the bargain, our space for thinking. I read somewhere that what made B. B. King a great blues guitarist was not just what he played but what he didn't play. The stuff he left for us to somehow complete. I'd say prose is more suited to the modern world because it fills almost all of the gaps. Most people don't like gaps, they don't like silence, they don't like being handed the pen.

A poem is a bit like constructing a story from a series of Polaroids. What isn't there is inferred by what is. We have to follow the clues, but that takes time. I've never heard any poem described as a page-turner. In fact, it would be a fabulously dismissive term for a poem that didn't warrant close inspection. Good poems always do.

Which is why, in this book, we're going to focus on a single poem: 'Pad, pad' by Stevie Smith. You're going to take my hand and we'll wander through the stanzas – a stanza is a sort of poetic paragraph, a separated lump of poem – shining a torch into its more interesting nooks and nuances. Does that sound daunting? Don't worry. Look, I'm a stand-up comedian by trade, not a professor. OK, I've got a Master's degree in English Literature, but that was a long time ago. I'm here as a fanboy, not as an academic. That's not to say I don't enjoy a difficult essay about Poetics or some hardcore technical chat about elision, inscape and poulter's measure, but there isn't much room for that stuff here.

What you'll hopefully get from going through 'Pad, pad' with me is a sense of how I, personally, read poetry. It's not based on any particular school of thought, and my method changes a bit with every poem I read. If you're just discovering poetry, this is a way of approaching it and, if you like it, or parts of

it, then you'll be able to apply your newly acquired investigative skills to any poem that takes your fancy. You should finish this book with a template for reading poetry that you can then customise at your leisure. And if you're already a poetry buff, you'll be able to enjoy the very special pleasure of being that person who deliberately goes on tours of places they know a lot about so they can cruelly undermine the floundering tour guide. Can't wait!

Why did I choose 'Pad, pad'? Well, on one level, it's fairly accessible. It's a story of love and loss, and I know you guys like all that stuff. After all, 96 per cent of all officially released pop songs and 98 per cent of all drunken phone-calls feature these two topics. Also, I really like the poem, and I really like Stevie Smith's strange, unsettling, ballad-like, domestic folk-tale poetry.

At this point, you'll be expecting a short biography of Ms Smith, outlining her childhood, her relationships, her personal tragedies. Forget it. The trouble

with biography, in this context, is the temptation to reduce a beautifully crafted poem to little more than a glorified diary entry. 'Ah, yes, the woman mentioned in the poem is almost certainly blah-blah who Smith had a brief blah-blah with in the summer of '47 . . .' Well, it might be, but so what? I have a rule, when I go to art galleries, that I always have a good long look at a painting before I read the little card on the wall beside it. That card, generally written by a middle-aged man in a Nehru jacket, someone who tends to be a fan of the biography thing, tells me how I should respond to the painting. It often has interesting facts and helpful critical analysis, so I do read it eventually, but not until I've formed a few thoughts of my own.

Because such factual information is inclined to close rather than to open minds. Once I'm told the woman in the painting was the artist's lover, and her name, and the fact that, at the time of painting, she'd just watched her younger sister die of cholera,

she loses a bit of her universality. She becomes an individual being with an individual story. There's no room for my response any more.

When, in my teens and early twenties, I got dumped, I would wallow in sad songs until the pain was soothed. It was like putting salt on a wound – a short period of considerable smarting followed by glassy-eyed numbness. Songs which included too much journalistic detail, like 'Delilah' or 'Jeanie with the Light Brown Hair', just didn't work. What if she was called Kim and was a peroxide blonde? This sounds facetious, but I'm trying to make a serious point. The biographical facts behind a poem are not the poem. They may well have supplied some of the materials in the formation of that poem, and that can be extremely colourful, but I'm not one of those people who'd rather read a book about Dylan Thomas than a book *by* Dylan Thomas.

Poetry, in my – if not humble, certainly insecure – opinion, is what the poem says and how it says it,

combined with my own response, the way I feel it, what it means to me. You may feel I give myself a bit too much credit when I suggest my response is actually part of the poem, but when a poet releases a poem out into the world, they relinquish sole ownership of it, for ever.

I once heard the writer Paul Muldoon describe the poet as the 'first reader' of a poem and thus as able to miss things about that poem as the rest of us. A poem, in some way, belongs to everyone who reads it. This part-ownership brings with it some responsibility. You must give the poem enough attention, enough analytical thought, enough experience of reading other poetry, to earn the right to have your name on the logbook.

So, what I'm about to offer you is *my* 'Pad, pad'. Hopefully, you'll go away and eventually build your own. Come on, then. Let's start reading. I'll try to wear my Nehru lightly.

Pad, pad

I always remember your beautiful flowers
And the beautiful kimono you wore
When you sat on the couch
With that tigerish crouch
And told me you loved me no more.

What I cannot remember is how I felt when you were unkind
All I know is, if you were unkind now I should not mind.
Ah me, the power to feel exaggerated, angry and sad
The years have taken from me. Softly I go now, pad pad.

Stanza One

I always remember your beautiful flowers
And the beautiful kimono you wore
When you sat on the couch
With that tigerish crouch
And told me you loved me no more.

Let's read those first two lines again.

I always remember your beautiful flowers
And the beautiful kimono you wore

I think many people, when first confronted with these
two lines, might have a flashback to a schoolteacher
telling them it's poor writing to use the same word

17

twice in close proximity. As a general rule, that is sage advice. But if Stevie Smith is boldly breaking such a rule in the first two lines of the poem by using the word 'beautiful' twice, it's a fair bet that she's doing it on purpose. As I've already pointed out, poets really, *really* care about words. The poet and critic Charles Simic once said a good poem is 'put together like the perfect crime'. The stakes are that high.

So why at the opening of 'Pad, pad' do we have a double 'beautiful', each one spoiling it for the other, like two unlucky debutantes arriving at the ball in exactly the same outfit? Well, in this context, I think it's a way of saying beautiful without saying beautiful, deliberately robbing it of its meaning. If someone recalls an event – and an important event, at that – and starts off by describing *everything* as beautiful, you'd be inclined to question their sincerity. 'Oh, this was beautiful and that was beautiful . . .' Suddenly it's a memory, the description of which is not even worth a casual flick through the thesaurus. One adjective will

do fine. It seems flippant. In 'Pad, pad', the 'beautifuls' are delivered underarm by the speaker – politely, rather than with conviction – and, interestingly, they aren't directly describing the person the poem is addressed to. The kimono and flowers are getting the praise, albeit diluted by repetition, but the person they adorned doesn't get a 'beautiful' of their own. There seems to be a glut of 'beautiful', but the speaker still couldn't manage to find any for the addressee. It seems to have been deliberately withheld. It feels pointed.

While we're kicking around 'beautifuls' and 'kimonos', allow me a poetic digression. In the poem 'In Memory of Eva Gore-Booth and Con Markiewicz' by the great Irish poet W. B. Yeats, he speaks of:

> *Two girls in silk kimonos, both*
> *Beautiful, one a gazelle.*

This exact phrase occurs twice in the space of eighteen lines, but this repetition feels very different from

Smith's. Yeats seems to be emphasising the specialness of that memory. He splits the sentence, I'm guessing, to deliberately place 'Beautiful' at the beginning of a line for extra emphasis and capitalised importance. There is no edge to this 'Beautiful'. Stevie Smith probably knew this Yeats poem and may – I'm saying 'may' – even have been deliberately alluding to it. It was published seventeen years before 'Pad, pad'. I'm not pushing that possibility, but I'd love to discover it was true, mainly because Yeats's poem has a bard-like gravity which makes a nice counterpoint for 'Pad, pad'. Yeats seems always aware of the great importance of poetry, especially his own. He speaks as from a pillar of fire. Smith has depth, speaks of loss and sorrow, but she's not a massive fan of bard-like gravity. One could imagine her writing a response to the Yeats poem in which the two girls, having read their description, post-publication, argue about which one is the gazelle.

Let's look at the next three lines:

When you sat on the couch
With that tigerish crouch
And told me you loved me no more.

These three lines seem almost comical. If you read them out loud, they sound like a limerick that's been in the same wash as 'The Owl and the Pussycat'. That rhyming couplet –

When you sat on the couch
With that tigerish crouch

– is hard to take seriously because its insistent rhythm and rhyme give it singalong feel. However, the addressee finally gets an adjective – or at least their crouch does – and it's 'tigerish'. Tigers are, of course, glamorous, graceful, sexy creatures, but to focus on their crouch is to focus on their predatory nature, their dangerousness, their savagery. The speaker, who now begins to emerge as a rejected lover, is intimating their own prey-status.

So, if it's such a dark image, why present it within such a bouncy rhyming couplet? I think it's because Stevie Smith likes the juxtaposition of the comic and tragic. Her poems often have something of the Music Hall macabre about them: the defiant grin, the greasepaint smudged by tears, the comic song delivered with a tuberculosis vibrato. This gives a real tension to her poetry – she can make us laugh *and* cry. I'm not suggesting you'll do both, or even either, but I exaggerate for emphasis.

This might be a good place to consider what rhyme does to this first half of the poem. I'd say that rhyme often gives the reader a sense of order, of pattern, a feeling that the world has a reassuring regularity. We may not know how the lines of our life are going to end, but at least we can predict what they'll sound like. An insistent rhythm in a poem can provide a similar refuge. Even if the poem is saying scary things, some solidity of form makes us think the sky is not ultimately going to fall on our heads. Metre

and rhyme can offer a bass clef of solid dependability to run under a treble clef of disorder and anxiety; it becomes a sort of emotional handrail. Again, I'm reminded of that Tom Jones classic, 'Delilah'. The song is about betrayal, murder and the pitfalls of stalking, but we're fine with it because it's such a bloody good tune.

Now, I'm generalising somewhat, of course, but bear with me for a moment. If we look again at this first stanza in 'Pad, pad', we might feel that the speaker has not been too badly mauled by their predator. Their tone has a jauntiness which suggests no real harm was done. They can look back glibly on the relationship now. Even the actual moment of rejection –

And told me you loved me no more.

– couldn't be more regular. De-DUM-DUM-de-DUM-DUM-de-DUM. Smith even creates the

effect with eight monosyllabic words to keep it nice and easy for us. In fact, maybe it's a bit too regular. Maybe the speaker is trying too hard to show they do not remain shaken by the experience. Maybe this is still-raw emotion forced into a regular metre and rhyme scheme to try and hide the continuing pain, as if 'Delilah's' tortured lover is inviting us to clap along. Let's now go back to those opening two lines:

> *I always remember your beautiful flowers*
> *And the beautiful kimono you wore*

We might now feel that second 'beautiful' was an early sign of the wheels coming off. It feels like it has a syllable too many compared with the uniformity of the metre elsewhere, and so it slightly wobbles the otherwise reassuringly regular rhythm. If Smith had made the kimono 'lovely' or 'silken', for example, there'd have been no repetition, no unsettling extra syllable, and the whole stanza would have been a house made

of bricks. But that would have been a con, wouldn't it? The structure of this reminiscence is much shakier than that. Smith seems to be offering us an early indication that the speaker is not as nonchalant as they seem.

The syntax – you know, order of words – of that last line of the first stanza is also worth noting:

And told me you loved me no more.

Putting 'no more' at the end gives it the feel of one of those lines you get in Victorian melodramas, with the actor down on one knee, forearm to brow, milking it for all they're worth. It's as if the only way the speaker can voice that awful rejection is to deliver it as a theatrical cliché. That gives them some distance from it. It is wrapped in the protective padding of Poetry with a capital 'P'. Having said all that, that 'no more' does ring out like a sonorous church bell at midnight. The duration of words can be crucial – should be crucial – in poetry. 'More' defies the staccato of

the rest of the line. It lingers. It leaves that first stanza echoing in our ears as we approach the second.

Before we move on, though, I'd like to say a word or two about punctuation. You may feel that poetry is a world of emotion, a world of feeling, and therefore too lawless to be fenced in by full stops, commas and colons. In fact, the poet is generally as meticulous about punctuation as they are about everything else. It's there to help us understand what's going on. Study it carefully.

For example, as I've suggested, that first stanza has, for me, something of the Music Hall comic recitation about it. Try reading it out loud, taking particular note of the punctuation. The Great Train Robbers had shorter sentences. One might reasonably anticipate a good round of applause for delivering it in the one mighty breath Smith seems to require. Spoken, it becomes a party-piece. One's comic momentum is partly down to the metre and partly down to a basic desire for oxygen.

Stevie Smith: A Digression

Let's pause between stanzas and consider a specific issue concerning this poem and poetry in general. Who is speaking here? Who is telling us about the kimono and the tigerish crouch? 'Stevie Smith,' I hear you mutter, but this wasn't meant to be a short-term-memory test. The question I'm asking is whose voice are we hearing in this poem? Even in a seemingly deeply personal poem, we have to be aware of the possibility of persona, of filter, of remove. Hence my tendency to refer to 'the speaker' rather than Stevie Smith in the above.

If we hear the speaker as Stevie Smith herself, unfiltered, then we begin to ask prying questions about the kimono-clad lover. The gender of the remembered ex

would, of course, have been a much bigger concern in 1950, but I don't care if Smith was gay – I just don't want to place her in a poem where I feel she doesn't want to be. If I'm honest, I enjoy the idea that the lover in the kimono, surrounded by beautiful flowers, is male. He's a guy I'd like to hear more about. I'm already aching for the second stanza to add a mother-of-pearl cigarette-holder to the description. But I actually think the gender of the lover is not really relevant. The lover seems to represent, at this midway stage, a predatory, vain, and perhaps cruel figure from the speaker's past. I find men and women are both equally capable of displaying these characteristics. If their gender is important, the poet will be sure to offer it up, eventually.

That said, there is an added complication here – a very Stevie Smith complication. She liked to accompany her poems with drawings. I quite like the drawings. They are simple, but have a certain energy. However, I really wish she'd kept these two

talents separate. Let me offer you an apposite anecdote. I went to an art-house cinema screening of a film about the American poet Allen Ginsberg and specifically about his poem 'Howl'. I love Ginsberg, I love 'Howl', and I really enjoyed the movie. At the end of it, two of the filmmakers did a Q&A. I asked if they were concerned about accompanying the long extracts from the poem with animated sequences that put pictures to Ginsberg's swirling, feverish verse. I went on to suggest, politely, that the animated images were giving answers to the audience that would have been better left as questions. They were filling in those lovely gaps I was talking about in the Introduction.

The two guys got very defensive and I had to interrupt their slightly paranoid response to point out that I'd really liked the film and was just curious about the general theory that poetry might benefit from some sort of supplementary imagery. In the end, they got impatient with me and turned to another questioner. They seemed much happier to consider his concern

that James Franco was too good-looking to play Gins-berg. Sod them. I preferred the book.

You see where I'm going with this. Good poetry is crammed with ideas, with sizzling sounds and rhythms, with linguistic fireworks. It doesn't need adornment. It's spilling over with richness. All it needs is the reader's undivided attention. That's it!

Stevie Smith's illustration for 'Pad, pad' shows a gormless-looking woman on a sofa, with flowers entwined in her hair. She is noticeably uncrouched and wears what looks more like a see-through Father Christmas robe than a kimono. The other figure – who we are, I feel sure, meant to identify as the speaker – is male, and looks like a down-at-heel post-war spiv, with a cigarette dangling off his bottom lip.

'Well,' I hear you say, 'that answers the gender question . . .' But there wasn't a gender question, was there? The illustration suggests that Smith has adopted a male persona. As I said earlier, there is something of the ballad about Smith's work, and the

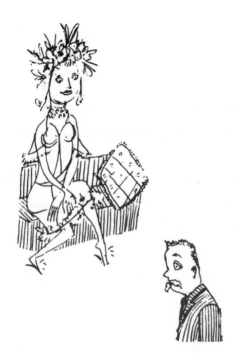

singers of such ballads would often take the voice
of a gender other than their own. 'Well done, then,
Frank,' I hear you say. 'Your earlier warning about
not automatically equating the voice of the poem
with the voice of the poet has turned out to be wise.'

No. I don't want that victory. I want us to explore the words, sounds and ideas in this poem. Any doodling in the margins just feels like a distraction. OK, one could argue that Smith was quite insistent on her illustrations being printed alongside her poems, so it's wrong to pretend that they don't somehow contribute to the overall meaning she wished to convey, but to me they feel more like an apology.

Allow me to share.

As I pointed out, the illustrations for 'Pad, pad' bear little relation to the mood of the poem. This non-connection is quite common in Smith's illustrated accompaniments. I'd love to believe that she is making the point that poetry is ambiguous, and thus deliberately confronting us with an interpretation that differs from our own. We are stopped in our self-satisfied tracks and made to think, 'Oh, maybe I should question my certainty about this poem. I had not even considered the spiv-loves-airhead theme.' I'm all for our interpretations of poetry being

regularly challenged and modified, but that is not how the drawings affect me. Stevie Smith often seems to be pulling the rug from under herself as she writes. It's that Music Hall thing, that comic self-awareness: 'I know poetry's a bit posh and pretentious, but I'm diluting that with a knowing wink to camera.'

To me, the illustrations are the act of someone who's slightly anxious about sincerity and seriousness in poetry, about sincerity and seriousness in art. Her drawings are the equivalent of the moustache drawn on the Mona Lisa. Or, perhaps, like someone writing a book about poetry but couching the whole thing in a cheery Jack-the-Lad-manner to avoid charges of getting ideas above one's station.

I could be completely wrong – I'm going to leave it up to you guys – but as we, torch at the ready, prepare to enter the second stanza, I won't be bothering to refer to the accompanying illustration again. I'm going to justify this by saying, in all honesty, that when I discovered this poem, in an anthology, when

I read it, slowly and repeatedly – as one must do with every poem that touches you in any way, especially after you foolishly think you've completely captured it and so don't need to read it slowly and repeatedly any more – it was not accompanied by the illustration. I knew nothing of the drawing till much later.

Therefore, I can say, in a book I acknowledge to be profoundly subjective, this poem, for me personally, existed separately from the illustration for all the formative years of our relationship. Discovering the drawing was like the poem's ex-husband turning up. It was hurtful and confusing, but it ultimately could not destabilise the image of her I had steadily developed. I love Stevie Smith, but I suppose I do slightly resent her using visual, non-poetic methods to try to influence my response to her words. As I said earlier, the poet's interpretation of the poem does not necessarily trump mine or that of any other attentive reader, and so to seek to impose it via an illustration sits in the same Venn diagram, for me, as those

two filmmakers trying to set visual ground-rules for how I should emotionally and intellectually respond to Allen Ginsberg's 'Howl'. Of course, any reader is free to disagree with me. Maybe I'll do a drawing of my argument to show them what they should think about it.

Stanza Two

> *What I cannot remember is how I felt when you*
> *were unkind*
> *All I know is, if you were unkind now I should not*
> *mind.*
> *Ah me, the power to feel exaggerated, angry and sad*
> *The years have taken from me. Softly I go now, pad*
> *pad.*

So, with that 'no more' still echoing in our ears, the speaker now moves from a largely visual description of that awful moment of rejection, from slightly comic rhymes and rhythms, to an opening couplet that reflects, with real poignancy, on the relationship and its continuing vapour-trail.

What I cannot remember is how I felt when you
 were unkind
All I know is, if you were unkind now I should not
 mind.

It's as if that 'no more' has destabilised the speaker and the poem itself. The almost jolly regularity of the first stanza has crumbled. If we read it aloud now, the fear of suffocation is slightly less – we have three sentences in this stanza as opposed to one in the first – but the sudden introduction of despair brings a discomfort all of its own. The first line of this second stanza is a very different animal from the last line of the first. We have moved from the melodramatic rhythms, the grand gestures of that last line to a sort of fifties kitchen-sink realism. I find this switch genuinely moving. Any attempt by the speaker to anaesthetise the pain by heavily encasing it in poetic, or comic, form has been abandoned. The words of this first line seem to lie where they fell, rather than having been carefully placed.

This is an illusion, of course. I think Smith knows exactly what she's doing. She led us to believe it was going to be one kind of poem and then presented us with another. The comic recitation tone of that first stanza has, it seems, now given her licence to properly examine what dysfunctional relationships do to people. There is no wink to camera here. This is broken talk. Try and say this first line in a jaunty fashion. You can't.

The second line, I think, attempts to stage something of a recovery. It provides the reassuring punchline of end-rhyme, of course – the 'I should not mind' begins to regain some regularity of rhythm – but I'm guessing some of you veterans of our long walk through the first stanza will have noticed a reflection of its opening here. The repetition of 'beautiful' is now echoed by the repetition of 'unkind'. I argued then that the double 'beautiful' devalued the word somewhat, but I think there is something different going on here. 'Unkind' is such

a loaded expression. It has a polite Englishness about it – very Stevie Smith – but the syntax places it at the end of the line, suggesting significance. This is the scream of the unsaid. Its understatement is powerful because the word's lack of savagery makes the victim seem more vulnerable. The stage is theirs. We're on their side. It's the perfect platform for bile. But the speaker, it seems, still can't fight back, and their continuing timidity makes the cruelty seem somehow more cruel.

Do I believe the speaker when they say, if the unkindness recommenced, they 'should not mind'? Well, here, I think, is another interesting example of the way form and content work together in a poem. For me, the speaker's certainty that they 'should not mind' is undermined by a return to regular rhythm, here, at the end of the second line. The speaker had seemed utterly derailed by the after-effects of the first stanza, but now they regain their grip with – I'm going to say it – two sturdy iambs (also known

as de-DUM de-DUM): 'I should not mind'. Rather than regain control, I think this sudden steadying of the rhythm of the line, of the stanza, feels like a return to the safety of the essentially regular metre of Stanza One – a reaching out for that handrail. Don't worry, that's as technical as this book is ever going to get. I just really want you to have an awareness of metre and rhythm in your toolkit when you look at other poems. They affect your reading of a poem much more than you think, like the score of a movie, manipulating your response to each scene.

OK. Now, as you've probably guessed, I'd never have led you into this particular poem in the first place if I couldn't present you with a knockout ending. Here goes.

Ah me, the power to feel exaggerated, angry and sad
The years have taken from me. Softly I go now, pad
 pad.

Oh, I love it. I love it. I want to take to the stage as the poem exits, and, gesturing towards it, announce: 'Ladies and Gentlemen, let's hear it for the human spirit. Still beautiful, even when broken.'

Anyway, calm down, Frank. Back to business.

So, the closing couplet is heralded by a sigh, as if the efforts of the preceding lines have now, finally, been abandoned. 'Ah, me', of course, has a theatrical tone perhaps more at home in the first stanza. It reminds me of lines by W. S. Gilbert (of 'and Sullivan' fame) from *The Yeomen of the Guard*:

> *'Tis but a foolish sigh – 'Ah me!'*
> *Born to droop and die – 'Ah Me!'*
> *Yet all the sense*
> *Of eloquence*
> *Lies hidden in a maid's 'Ah me!'*

Thus, Gilbert offers his own school of poetic analysis. He acknowledges the Tardis-like nature of what

could easily be dismissed as 'a foolish sigh' but what, in fact, is bigger on the inside. (Those of you unsettled by me now applying the Tardis analogy to an opera written in 1888 have underestimated the cross-reference capacities of time travel.) I might say that Gilbert, in these lines, justifies the whole process of close-reading, of taking a magnifying glass to language and finding 'eloquence' where a surface reading might suggest little more than an exhalation of breath. 'Ah, me!' can get pretty deep.

But back to 'Pad, pad'. The whole poem, it seems now, has been an effort to conjure up a past emotion that isn't quite there any more. Or has it? The speaker doesn't, we're told, feel angry or sad like they used to. I especially love the idea of losing 'the power to feel exaggerated'. That is such a sharp image of what being in love is like, the complete loss of the middle register. I remember physically falling to my knees once because the woman who was, at that point, at the centre of my emotional universe, had sent me

a text with no 'x' on the end. Of course, one gets the rewards of corresponding highs, but the whole enterprise, as the speaker suggests, requires a great deal of energy.

This ending takes us back to that point I was making about the reader's part-ownership of a poem. Our response, shot through with all our experiences, foibles, fears, attitudes, aspirations, completes a poem. The ending of 'Pad, pad' has a lot to do with the reader. Is 'the power to feel exaggerated' a power or is it a weakness? Is losing that capacity for emotional intensity a loss or is it a liberation? Do we believe that the speaker is so stoical, considering the tear-stained first line of this stanza?

The closing couplet plays fast and loose with us. The 'Ah, me' suggests mournful regret, but how do we respond to the final sentence of the poem?

Softly I go now, pad pad.

Even if these are the words of someone broken and emotionally reduced by 'the years', it's still a classy, onomatopoeic exit. It reminds me of a great closing line, used by old comedians: 'I will leave the stage now, accompanied by my theme tune: the sound of my own footsteps.' Maybe I could speak as a stand-up comedian, for a moment. The reason this old line is funny, in my opinion, is that the comic is acknowledging his own fragility. He anticipates the humiliation of leaving the stage to no applause, but by openly referring to this possibility he somehow makes his failure dynamic – epic, even. He is not pretending the show has gone well. In fact, by suggesting a silent exit is, for him, so common it constitutes a theme tune, he gives the audience extra information on his disgrace: it happens a lot, a fact that one might expect him to guard safely. The audience may deduce from all this that their response is not crucial to him. This cockiness, if delivered with charm rather than aggression, can be very alluring. But, of course, the

comic may just be taking out insurance, pretending he can't be hurt, trying to reduce the humiliation by setting the agenda himself, beating the audience to the punch and then rolling with it.

I think all this can throw some light on the ending of 'Pad, pad'. That last couplet could be read as a tragic admission: the speaker's light has gone out, all passion subsided. These things were, it seems, not given up voluntarily, not put to one side. They were, the speaker explains, 'taken from me'. But, for me, that 'pad pad' – the voicing of it – changes everything. It is one last look back at the audience, a parting smile. This is Stevie Smith at her most Music Hall. The performer opens their heart to the audience but still leaves them laughing. There is also something cat-like about 'pad pad'. It gives the ending a tone of feline indifference, of Sphinx-like inscrutability, of triumph. The tigerish lover, with all their big-cat glamour, has been trumped by the deeply domestic but ultimately aloof speaker. A cat

can look at a queen and, even more empoweringly, also choose not to.

The poem is entitled 'Pad, pad', so we are encouraged to view that last gesture as extremely significant. Maybe that's why the unkind ex-lover gets off quite lightly. When, in the past, I've pointed a finger at lovers who I feel have treated me cruelly, I've had, to hand, lists of illustrative incidents to back-up my accusations and I've referred to them at length. They who 'pad pad', however, just sprinkle a little poison, control that slight quiver in their bottom lip, and then move almost silently on. And it all rhymes!

Conclusion

I love this poem. Some may feel I've 'read too much into it', but don't blame me. Blame poets – poets and their habit of WRITING so much into it. Was Stevie Smith aware of all the effects I've referred to in this book when she wrote the poem? Probably not. That's the thing with good poets. They structure and decide and re-write and insert, but some of the magic comes from a place beyond intention. It just falls from them like windfall fruit. And, of course, I, the reader, am invited to frolic in those big white gaps – and frolic I do.

I suggest you read 'Pad, pad' again, now, not stopping to re-live every point we've discussed here, but rather to let the memory of this book be the wind

beneath your wings. And you'll need all the extra wind you can get to declaim that first stanza. I hope you feel the experience has been ever so slightly enriched. And when you read your next poem, and the one after that, please give a thought to some of the things we've shared.

Oh, and if, despite all I've said, you're still hungry for biography, there's a really good film called *Stevie*, with Glenda Jackson portraying the poet.

You could probably also get a badge.

Read more poetry. I honestly believe it will change your life as it continues to change mine. I still love the sheer thrill, the continuing realisation that two human beings – poet and reader – can somehow communicate on such an intense emotional, intellectual, and indeed mystical level. It is that exhilarating connection that is at the core of poetry for me.

But, obviously, I wouldn't tell anyone that.